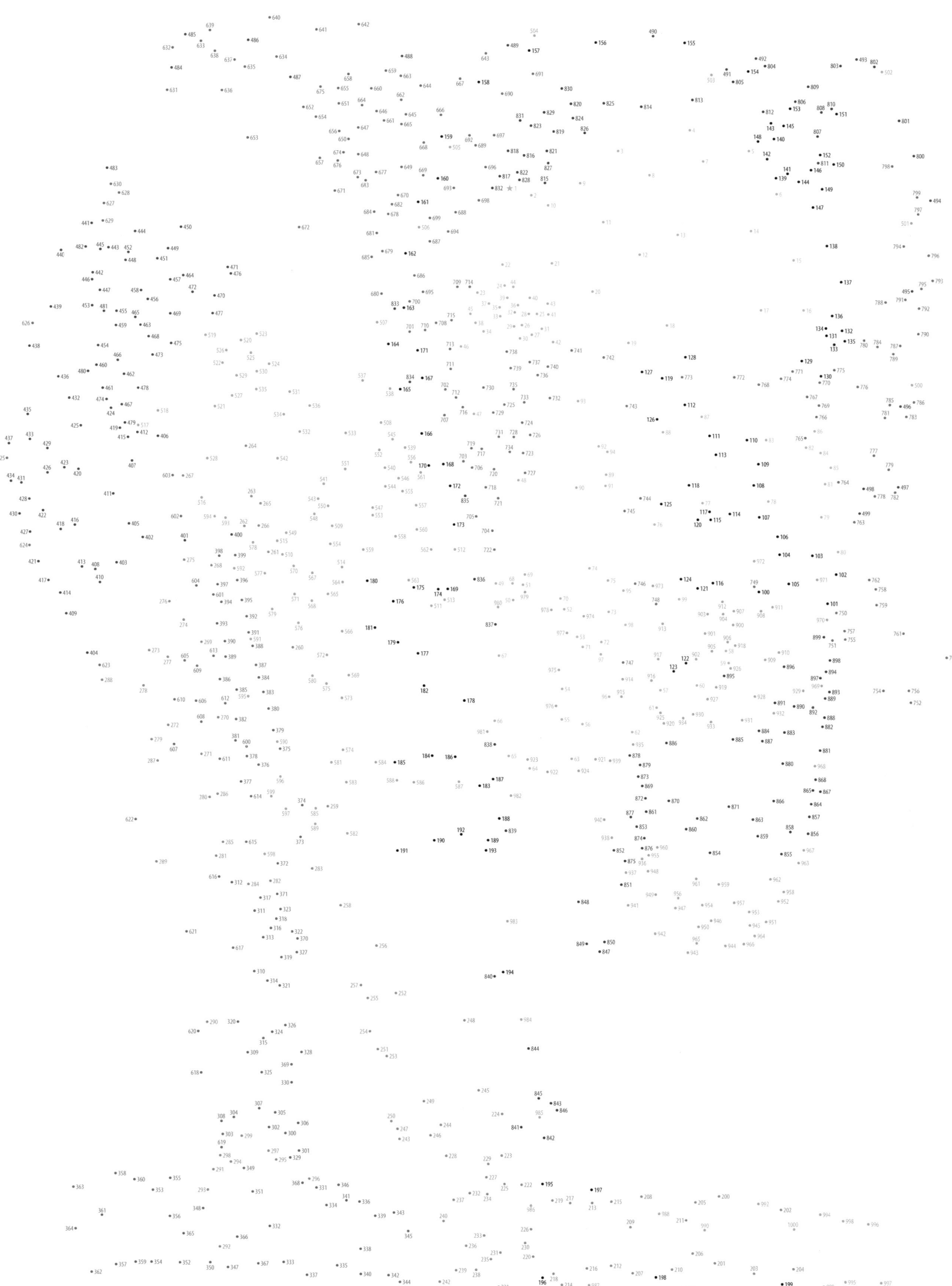

CAT CHIMPANZEE CROCODILE DOG DOLPHIN

ELEPHANT FOX FROG GIRAFFE HORSE

KOALA PANDA PARROT PEACOCK PIG

RABBITS SLOTH SNAKE TIGER TURTLE

ACKNOWLEDGMENTS

This book is dedicated to my favorite animals, Robbie and Phoebe,
two beautiful Siamese cats who live at my parents' home in Auckland.